THE POCKET

Pharrell Williams

Published in 2025
by Gemini Books
Part of Gemini Books Group

Based in Woodbridge and London

Marine House, Tide Mill Way,
Woodbridge, Suffolk IP12 1AP
United Kingdom
www.geminibooks.com

Text and Design © 2025 Gemini Adult Books Ltd
Part of the Gemini Pockets series

Cover illustration by Natalie Floss

ISBN 978-1-80247-278-3

All rights reserved. No part of this publication may be reproduced in any form or by any means – electronic, mechanical, photocopying, recording or otherwise – or stored in any retrieval system of any nature without prior written permission from the copyright holders.

A CIP catalogue record for this book is available from the British Library.

Disclaimer: The book is a guidebook purely for information and entertainment purposes only. All trademarks, individual and company names, brand names, registered names, quotations, celebrity names, logos, dialogues and catchphrases used or cited in this book are the property of their respective owners. The publisher does not assume and hereby disclaims any liability to any party for any loss, damage or disruption caused by errors or omissions, whether such errors or omissions result from negligence, accident or any other cause. This book is an unofficial and unauthorized publication by Gemini Adult Books Ltd and has not been licensed, approved, sponsored or endorsed by Pharrell Williams or any other person or entity.

Printed in China

10 9 8 7 6 5 4 3 2 1

Images: Alamy: 4 /Matt Crossick; 7 /WENN Rights Ltd; 8 /Grzegorz Czapski; 32 /Suzan Moore; 60 /PA Images; 94 /Associated Press. Freepik: 21, 38.

THE POCKET

Pharrell Williams

G:

CONTENTS

Introduction 06

Chapter One:
Musical Prodigy Loading 08

Chapter Two:
The King of Collabs 32

Chapter Three:
Happy Vibes 60

Chapter Four:
Cultural Icon 94

Pharrell Williams

Introduction

You can try and shoehorn Pharrell Williams into one category of creative, but he wears wayyyy too many hats for that (including of course his signature "Big Hat", debuted at the 2014 Grammys). He's a musician, rapper, producer, fashion designer and style icon. Pharrell is the epitome of effortless cool.

Musically, his own catalogue is impressive in its own right; he's produced on, collabbed with and written some of the greatest tunes of all time for the likes of Jay-Z, Britney Spears, Nelly and Daft Punk. On top of that, the man knows how to dress. He'd already been a fashion trailblazer for decades before becoming creative director at Louis Vuitton in 2023.

There's not much that Pharrell *can't* do – and everything he does is one of a kind, just like him. Welcome to a pocket-sized dose of a living legend.

Chapter One
Musical Prodigy Loading

Pharrell Williams

A True Aries is Born

On 5 April 1973, Pharrell Lanscilo Williams' birthday, the stars hinted at who he would become. He was born an Aries, the zodiac sign known for being ambitious, energetic, passionate and fearless. No one could have known then just how well Pharrell would fit that description!

At that time, though, Pharrell was simply the first-born son to Pharoah, a handyman, and Carolyn, a teacher, who would later welcome two more boys into their family. Pharrell grew up in Virginia Beach, Virginia, raised, as he remembers, on Earth, Wind & Fire.

Musical Prodigy Loading

"I am different. I am weird ... I don't fit in your world. You want to know why? Because I'm OTHER."

Pharrell, interview on CNN,
20 December 2013

Pharrell Williams

> **Pharrell Williams is arguably the most important creative mind of our generation.**

Grant Brydon, *Clash*, 7 September 2018

Musical Prodigy Loading

Grandma Knows Best

We may not have known Pharrell Williams in the capacity we do today if it wasn't for his grandma's wisdom. By the seventh grade, the young Pharrell had already shown an interest in music, but his grandma was the one to encourage him to take it more seriously.

So, 12-year-old Pharrell attended a summer camp for gifted students, with a stoked fire in his belly. And it was there he met a fellow aspiring pre-teen musician, Chad Hugo, who played the tenor saxophone (a great complement to Pharrell's chosen instruments: the keyboard and drums). The duo hit it off like a pair of cymbals – get it? – and by lucky coincidence they attended the same school, so they were able to continue their fledgling partnership when summer camp ended, and the Neptunes were born.

Pharrell Williams

Even before the extra-planetary genius of the Neptunes graced our galaxy, Pharrell was intertwined with greatness.

Said to have attended the same church as rapper Timbaland, the pair joined forces in the early 1990s with fellow rapper Magoo to cut tracks under the name Surrounded by Idiots.

Musical Prodigy Loading

> **So many people just have that innate thing that allows them to express themselves in a way the majority can follow. That's when you're affecting culture.**
>
> Pharrell, interview on CNN,
> 20 December 2013

Pharrell Williams

> **I always knew I was going to do music, I just never knew what – whether I would end up as a terrible music teacher or an art teacher who was always asking his friends to come over and play on the side. But this was how it was written, and I give thanks every day.**

Pharrell, interview in the *Guardian*, 12 January 2023

Musical Prodigy Loading

Credit Where It's Due

In an April 2014 interview with CBS News, Pharrell acknowledged all the teachers who guided his first musical footsteps. He shocked interviewer Anthony Mason by remembering all their names decades later.

Mason: "You remember them all?"

Pharrell: "Yes, I do ... My story is the average story, you know. It's just filled with special people."

Mason: "You're giving everybody else credit."

Pharrell: "Well, what am I without them?"

Pharrell Williams

Meet the Neptunes

In the early 1990s, after their successful summer collab, Pharrell and Hugo met back up at their Virginia Beach high school, where they joined the school jazz band – and also began one of their own.

The Neptunes – an R'n'B four-piece with friends Shay Haley and Mike Etheridge – was born. Despite that otherworldly name, they didn't *quite* start churning out a new sound right away.

Neptunes co-founder Chad Hugo told Aussie music magazine *The Age* in 2004:

"Have you seen that movie *School of Rock*? That was us, except we played jazz standards."

Musical Prodigy Loading

Keen skateboarder Pharrell's nickname in high school was

Lil' Skateboard P

Other nicknames he goes by are:

Sk8brd, Auto Goon, Magnum, the Verb Lord and Station Wagon P

Pharrell Williams

✳
Why "the Neptunes"?

Some say it's because the planet Neptune, astrologically speaking, rules the water. And the Earth is mostly made of water. So, if you think of it that way, then the Neptunes might just have thought they were going to rule the world.

Musical Prodigy Loading

A Talent-filled Talent Show

So many high schoolers think their garage band is going to make it big. If the Neptunes envisioned that for themselves, well, they weren't that far off.

Even crazier is that they got their big break during a 1992 school talent show. Producer Teddy Riley, a pioneer of music genre new jack swing and frontman of the group Blackstreet, just so happened to open a music studio *next door* to Pharrell's high school.

So, Riley stopped by to check out the show, heard the Neptunes, and immediately knew this was no ordinary teen band …

Pharrell Williams

What is "New Jack Swing"?

You may not be familiar with the genre of new jack swing, but we bet you've heard it.

New jack swing – brought to the forefront in the 1980s and '90s by producers Teddy Riley, Jimmy Jam and Terry Lewis – weaves together rap, funk, jazz and R'n'B sounds to create melodic pop songs. It's also famous for sampling classic beats to make something fresh and fun.

Some of the best new jack swing songs of all time (all produced by Riley) include: Johnny Kemp's 'Just Got Paid', Michael Jackson's 'Remember the Time' and Bobby Brown's 'My Prerogative'.

Musical Prodigy Loading

Not Your Average High School Job

Most high schoolers pick up unglamorous part-time jobs to make a little bit of spending money. That was not the case with Pharrell, who, alongside his Neptunes bandmate Hugo, got hired by Riley, a now-legendary producer.

The high schoolers weren't just studio interns, either – they were fully fledged producers and songwriters, and it didn't take long for them to make their mark.

Pharrell Williams

Virginia Is for (Music) Lovers

Teddy Riley moved his studio to Virginia because, as he told Red Bull Music Academy, "As far as talent and major producers go, Virginia is right at the top." Along with Pharrell and Hugo, some of the most famous artists hailing from this southern state include:

- **Timbaland**
- **Ella Fitzgerald**
- **Patsy Cline**
- **Missy Elliott**
- **Dave Matthews Band**
- **Pusha T**
- **Trey Songz**
- **Chris Brown**
- **Jason Mraz**

Musical Prodigy Loading

25 August 1992

Pharrell got his first song-writing credit on 'Rump Shaker' by Wreckx-n-Effect, which came out on this summer day. Specifically, he wrote the verse performed by Teddy Riley, a guest vocalist on the track.

In an interview in HipHopDX in December 2020, Riley recalls how Pharrell's writing had risen to the top of all the other verses he'd tried:

"I produced the song, and there were so many versions of it, and I didn't like the way my rap was. This was my chance to give Pharrell the opportunity to write it. He said, 'I can come up with something.' I said, 'Well, let's do it.' He came up with the rap."

Pharrell Williams

A No. 1 Hit

The Neptunes continued producing with Riley throughout the early 1990s, sticking to his new jack swing and R'n'B stylings during this stretch of their career.

The highlight of this period might have been their work on the remix of SWV's 'Right Here', which spent seven weeks on top of the Billboard Hot R'n'B Singles chart.

Musical Prodigy Loading

At the beginning of 'Right Here', you can hear Pharrell shouting, "S … Double U … To The V!"

Girl group SWV adopted this chant and used it as a rally cry at their concerts.

Pharrell Williams

Branching Out

By the late 1990s, the Neptunes were spreading their musical wings – and found themselves flying with something completely different to the new jack swing that gave them their start.

Soon some of hip-hop's biggest stars of the time were practically banging down the door in search of their production prowess.

Music journo Ryan Bassil described the Neptunes' new sound as a "fashionable melange of psychedelic pop, classic rock and new wave". (*VICE*, 26 September 2013.)

Musical Prodigy Loading

> **Those guys were so ahead of their time. Their sound was ahead of its time, so there were certain things that we didn't know – if their sound was going to make it back then, but maybe in the future. That's what the Neptunes were about. They represented the future.**

Teddy Riley, interview with the
Red Bull Music Academy, 2015

Pharrell Williams

The Definition of Eclectic Taste

Pharrell is well known for merging genres and breaking moulds. In an interview with the *Guardian* in September 2010, he laid out some seminal influences:

- **Earth, Wind & Fire, 'Can't Hide Love' (1975)**

- **Stevie Wonder, *Songs in the Key of Life* (1976)**

- **The Jacksons, 'Shake Your Body (Down to the Ground)' (1978)**

- **Afrika Bambaataa & the Soul Sonic Force, 'Planet Rock' (1982)**

- **A Tribe Called Quest, 'Bonita Applebum' (1990)**

Musical Prodigy Loading

> We get inspired by 'like' things we see or hear or things we encounter, experiences. But then there are moments when those things run out, when you have nothing else and you're tapped out. That is the best place you could ever be, because now the only thing you have is intuition.

Pharrell, interview on CNN,
20 December 2013

Chapter Two
The King of Collabs

Pharrell Williams

> \\ I'm not a mainstream kind of artist … I'm, you know, quirky, often seen as a weird guy behind the boards, and I totally appreciate my position in the system, you know what I mean? \\

Pharrell, interview with *Ask Men*, 2007

The King of Collabs

The Beat Goes On …

The time had come for the Neptunes to step out of Riley's shadow and do their own thing. In July 1998, within a month of release, the duo's first track, Mase's 'Lookin' at Me' was certified gold on the Billboard charts after peaking at No. 8 on the Hot 100.

They soon followed up in September of that year with another Top 10 Billboard Hot 100 hit – 'Superthug' by Noreaga – establishing the Neptunes as sought-after producers in their own right.

Pharrell Williams

✷
A New Millennium

While everyone else was worrying about whether Y2K would destroy all systems the world over, Pharrell and Chad Hugo were surely plotting to take over the music industry, because that's pretty much what they did – starting in the year 2000.

That year, the Neptunes produced Jay-Z's 'I Just Wanna Love U' – featuring Pharrell on vocals, too – giving him his first No. 1 single on the Billboard Hot Rap chart.

The King of Collabs

According to music journo Craig Jenkins, 'I Just Wanna Love U':

"…typifies the early Neptunes sound, which was an economic pairing of defiantly artificial clavichord hits and spacious boom bap drums, adorned with additional layers of synthetic hand percussion sounds."

Complex, 5 March 2013

(If you don't know what that means, we suggest you stream the song right now.)

Pharrell Williams

The ... Clavichord?

Leave it to Pharrell to incorporate an instrument from the Middle Ages into modern-day hip-hop beats.

What is it?
The clavichord resembles a piano or keyboard. It doesn't produce sounds loud enough to be used in performances, but is perfect in a studio setting.

What does it sound like?
Confusingly, the clavichord looks like a keyboard, but sounds more like a twangy guitar. That's because the keys pluck strings, just like guitarists do.

Why did Pharrell love it so much?
We'll let him tell you in his own words...

The King of Collabs

> **The clavichord was a way to express Middle Eastern note patterns and chord progressions, but to also be raspy like a guitar.**

Pharrell, interview in the *Guardian*, 2023

Well, there you have it.

Pharrell Williams

Pop Royalty Meets the Neptunes

For their first few years as solo producers, the Neptunes worked almost solely with hip-hop and R'n'B artists. But soon enough, pop stars came a-knocking in search of their own collabs with the production duo.

Some of the biggest radio hits of the early 2000s were produced by Pharrell and Co., including bops by Britney Spears and Justin Timberlake, arguably the prince and princess of pop at the time.

The King of Collabs

Pop Hits Produced by the Neptunes

'I'm a Slave 4 U' – Britney Spears (2001)
'Boys' – Britney Spears (2001)
'Señorita' – Justin Timberlake (2002)
'Like I Love You' – Justin Timberlake (2002)
'Rock Your Body' – Justin Timberlake (2002)
'Hollaback Girl' – Gwen Stefani (2004)

Pharrell Williams

> **The gift of creation is amazing, and something as simple as a conversation is your own creation – you use those words with your tone.**

Pharrell, interview in *Clash*,
7 September 2018

The King of Collabs

La-la, La, La, La

Another smash hit that we can thank Pharrell for: **'Milkshake' by Kelis (2003).**

At this point, you'd be hard pressed to find someone who hears the word "milkshake" and doesn't instantly start singing the song. It's gone so far that Kelis has since said that it ruined the drink for her. She told *The Age* in 2024:

"It's not super fun to order [milkshakes] … My kids will ask, 'Can we get a milkshake?' and I just have to say … no."

Pharrell Williams

More Noughties Neptunes Bangers...

'Hot In Herre' – Nelly (2003)
'Drop It Like It's Hot' – Snoop Dogg featuring Pharrell (2004)
'U Don't Have to Call' – Usher (2001)
'Shake Ya A'** – Mystikal featuring Pharrell (2000)
'Young'n (Holla Back)' – Fabolous (2002)
'Excuse Me Miss' – Jay-Z (2003)

The King of Collabs

" **I find that it always works when you find the interesting friction, the interesting alchemy between two things [voice and genre], the juxtaposition that, to me, makes for very interesting music.** "

Pharrell, interview on CNN,
20 December 2013

Pharrell Williams

N.E.R.D.

As if he wasn't already smashing the Noughties, in 2001 Pharrell began a side project that merged strong 1970s rock and funk influences with his hip-hop/R'n'B roots.

N.E.R.D. – "No-one ever really dies" – comprised Pharrell and fellow Neptunes members Hugo and Shay Haley.

Born out of a desire to add more live music into the heavily synthesized sounds of hip-hop, Pharrell describes how:

The King of Collabs

> **The music felt constricted, layered through keyboards … Now it's become an eagle flying off of all these cliffs.**

Pharrell, on creating N.E.R.D.'s sound, interview in *MusicWorld*, December 2002

Pharrell Williams

"When he feels like he's too glossy, he has to figure out how to muddy himself back up again."

Shae Haley, on Pharrell's need for N.E.R.D., interview in *The New York Times*, 7 January 2017

The King of Collabs

N.E.R.D.'s reception from rock publication communities was positive; while hip-hop reviews were mixed.

The band have produced four albums, two of which reached gold status: *In Search Of…* (2001) and *Fly or Die* (2004) – and continued to produce and perform through the Noughties and the 2010s.

The band's last appearances to date were in 2017 at the Nickelodeon Kids Awards and the UK's Reading and Leeds Festivals.

Pharrell Williams

Stars on Track

Pharrell is a massive *Star Trek* fan – so much so that he named his production company after the sci-fi show.

Star Trak was founded in 2001, and its logo is heavily influenced by the Vulcan salute.

The label thrived for a dozen years before shutting down in 2015.

The King of Collabs

Artists once on the Star Trak roster:

* Charles Hamilton
* Chester French
* Clipse
* Fam-Lay
* The High Speed Scene
* Kelis
* Kenna
* The Neptunes (of course)
* N.E.R.D. (of course)
* Pharrell (of course!)
* Robin Thicke
* Slim Thug
* Snoop Dogg
* Spymob
* Super Cat
* Teriyaki Boyz
* Teyana Taylor

Pharrell Williams

In 2003, 43 per cent of songs played on US radio and 20 per cent of songs played on UK radio were produced by the Neptunes.

The King of Collabs

Grammy Golds

It was only a matter of time before the Neptunes' work was recognized on music's biggest night. In total, they've received ten nominations, winning four gramophones.

Wins:

- Producer of the Year, Non-Classical (2004)
- Best Pop Vocal Album for *Justified* by Justin Timberlake (2004)
- Best Contemporary R'n'B Album for *The Emancipation of Mimi* by Mariah Carey (2006)
- Best Rap Song for 'Money Maker' by Ludacris featuring Pharrell (2007)

Pharrell Williams

Stepping Out Solo

On 3 June 2003, Pharrell dropped his debut solo single, 'Frontin'' featuring Jay-Z.

At the time, he vowed that this was a one-off, that he had no plans to release any more solo music because he saw himself as a producer and not a musical artist. (Of course, this was not always going to be the case ...)

Fifteen years after 'Frontin'' debuted, Pharrell revealed that he hadn't written the song for himself, but for one of his fellow greatest-of-all-time artists.

The King of Collabs

> "All of my biggest songs were songs that I did with or for other people. Collaboration has always been part of my DNA. And, to be clear and to be honest, songs that I ended up putting out by myself were always songs that I wrote for other people. I made 'Frontin'' for Prince. [...] Imagine if Prince had sung 'Frontin''? Come on!"

Pharrell, interview in *Clash*,
7 September 2018

Pharrell Williams

*
In Pharrell's Mind

Three years after dropping 'Frontin'', Pharrell seemingly changed his mind about releasing his own tunes.

On 25 July 2006, out came *In My Mind*, his first studio album, which would earn him a Grammy nomination for Best Rap Album (although Ludacris's *Release Therapy* would take the big prize).

The King of Collabs

The Track List – *In My Mind*

1. 'Can I Have It Like That' (ft. Gwen Stefani)
2. 'How Does It Feel?'
3. 'Raspy Shit'
4. 'Best Friend'
5. 'You Can Do It Too' (ft. Jamie Cullum)
6. 'Keep It Playa' (ft. Slim Thug)
7. 'That Girl' (ft. Snoop Dogg and Charlie Wilson)
8. 'Angel'
9. 'Young Girl'/'I Really Like You' (ft. Jay-Z)
10. 'Take It Off (Dim the Lights)'
11. 'Stay With Me' (ft. Pusha T)
12. 'Baby' (ft. Nelly)
13. 'Our Father'
14. 'Number One' (ft. Kanye West)
15. 'Skateboard P Presents: Show You How to Hustle' (ft. Lauren)
16. 'Swagger International' (Japan Bonus Track)

Pharrell Williams

Pharrell On Screen

Not one to stay in his lane, Pharrell has broadened his reach into the worlds of film and TV.

In 2016 he co-produced the soundtrack to *Hidden Figures*, for which he won a slew of accolades.

In 2018, Pharrell narrated Universal's remake of the classic film *The Grinch*. In the same year, he produced educational science series *Brainchild* for Netflix.

The King of Collabs

In October 2024 his autobiographical animated film *Piece by Piece* was released. Set in the Lego-verse, and produced by Pharrell, this unique take on a bio-pic is nothing but expected …

Almost too coincidentally, part of Pharrell's Spring 2024 collection for Louis Vuitton included pixelated, "brick-like" patterns, dubbed "Damouflage".

Chapter Three
Happy Vibes

Pharrell Williams

30 Minutes

This is the amount of time it would take Pharrell to catapult to the top of the Billboard charts.

It all started in July 2012, when Pharrell started work on singer Robin Thicke's album. (The soulful songster was signed to Pharrell's label, Star Trak.) The duo met in the studio and started work on a new song, which reportedly took less than an hour to create.

Happy Vibes

July 2012 Production Notes

On that day in the studio, Pharrell started to play a funky rhythm, alongside a very simple two-chord progression. He topped it off with some syncopated cowbell chimes.

Then, Thicke took over, and started improvising over his producer's beat. He imagined a man who was trying to steal his friend's girlfriend, and the lyrics started flowing.

Within half an hour, he and Pharrell had written a new song together. The name? 'Blurred Lines'.

Pharrell Williams

'Blurred Lines' in Numbers

'Blurred Lines' was released on **27 March 2013**, and went on to spend **12 consecutive weeks** at the top of the Billboard Hot 100 chart. That made it **the longest-running No. 1 single** in the USA in 2013.

The song also topped the charts in **25 countries**. In **six other countries,** it reached the **top five**.

Happy Vibes

'Blurred Lines' sold **14.8 million copies** making it one of the most successful singles of all time.

The song received **two Grammy nominations** in 2014 – Record of the Year and Best Pop Duo/Group Performance.

Pharrell Williams

(A Note on the 'Blurred Lines' Backlash)

Despite its success, 'Blurred Lines' did raise some eyebrows based on the double meaning that some interpreted the lyrics to have. Six years on, Pharrell took accountability for this.

In November 2019 Pharrell graced the cover of *GQ* for their "New Masculinity" issue. He told the magazine that he was "embarrassed" about some of the lyrics of his previous hits.

Happy Vibes

>> **It doesn't matter that that's not my behavior. Or the way I think about things. It just matters how it affects women. And I was like, 'Got it. I get it. Cool.' My mind opened up to what was actually being said in the song and how it could make someone feel.** <<

Pharrell, interview in GQ,
15 October 2019

Pharrell Williams

"If you just want me to play a tambourine, I'll do it."

Pharrell, interview with
VICE and Intel's Creators Project, 2013

Happy Vibes

Nothing Daft About That

While 'Blurred Lines' absolutely dominated 2013's Billboard charts, there was another song on its heels for a solid five weeks: 'Get Lucky' by Daft Punk. We'll give you one guess as to who produced that song ...

Pharrell recalled that he was so desperate to work with Daft Punk that he offered to just play percussion on a track, when he met them at a party thrown by Madonna (humble brag).

Pharrell's contribution ended up being much more substantial. He provided lead vocals, while legendary American musician Nile Rodgers added a guitar riff to the song.

Pharrell Williams

*
'Get Lucky' in Numbers

Just like 'Blurred Lines', 'Get Lucky' has a pretty impressive post-release CV. Let's run the numbers:

It took **18 months** for Daft Punk to finish making 'Get Lucky'.

The song reached **No. 2** on the US Billboard Hot 100 chart, hanging on in that position for **five consecutive weeks**.

Happy Vibes

In the UK, 'Get Lucky' reached No. 1 and stayed there for four weeks. It was also the country's second best-selling single of 2013, as it sold a whopping 1,308,007 copies.

Pharrell Williams

A Grammy Double

Daft Punk, Nile Rodgers and Pharrell brought home two Grammy Awards for 'Get Lucky' in 2014:

- **Record of the Year**
- **Best Pop Duo/Group Performance**

(…beating 'Blurred Lines' for those two gramophones).

And *Random Access Memories*, Daft Punk's album that included 'Get Lucky', earned them and Pharrell another Grammy for Album of the Year, too.

Happy Vibes

History Maker

When 'Get Lucky' nabbed the No. 2 spot just behind 'Blurred Lines', Pharrell made history: not many artists have held the No. 1 and No. 2 spots on the Billboard charts at the same time.

He's in good company with the likes of ...

- **Bee Gees**
- **The Beatles**
- **BTS**
- **Black Eyed Peas**
- **OutKast**

Pharrell Williams

40 Was a Good Year!

Pharrell turned 40 just after 'Blurred Lines' hit radios everywhere – and just before 'Get Lucky' followed suit. But those weren't the only highlights of his milestone year.

On 12 October 2013, Pharrell married his long-time girlfriend, model and fashion designer Helen Lasichanh. The journey to forever started with a long-standing friendship that kicked off in the early Noughties, although Pharrell knew he wanted it to be more from the start.

Happy Vibes

"I knew at some point something was going to happen. I was just so enamoured by the moment I was having with her. I just wanted to read that book. I didn't care what was in it."

Pharrell, on his wife, Helen Lasichanh, interview in *OWN*, April 2014

Pharrell Williams

Lift Off

Once Lasichanh and Pharrell became more than friends – two years after they had first met – their relationship took off like, well, a rocket. But that's not why they named their first child, born in 2008, Rocket. His name had three sources of inspiration:

- **'Rocket Love' by Stevie Wonder**
- **'Rocket Man' by Elton John**
- **'Rocket' by Herbie Hancock**

(The couple would later also welcome *triplets* to complete their family in 2017, although even all these years later, they have yet to reveal their names.)

Happy Vibes

〝 Helen and I having Rocket, it's been awesome. It's the best song that I've ever co-written, but it's a song that keeps co-writing itself, too. Like, he changes his bridge all the time, but as you hear each version of his bridge, you keep seeing the rhythm. 〟

Pharrell, interview in *Complex*, 2013

Pharrell Williams

> **There is no breathing human being on this planet that did not benefit by a woman saying yes twice. Yes to make you, and yes to have you. Point-blank.**

Pharrell, interview in GQ, February 2014

Happy Vibes

Female Inspo

Pharrell's second solo studio album,
G I R L, was the long-awaited follow-up
to 2006's *In My Mind*.

In an interview with *GQ*, Pharrell revealed that
he had come up with the title and concept for
this album before recording a single track.

It turned out that the women in his life
– including his wife, of course – had opened his
eyes to a simple, musically inspiring truth.

Pharrell Williams

The Track List – *G I R L*

1. 'Marilyn Monroe'
2. 'Brand New' (ft. Justin Timberlake)
3. 'Hunter'
4. 'Gush'
5. 'Happy'
6. 'Come Get It Bae'
7. 'Gust of Wind'
8. 'Lost Queen'
9. 'Know Who You Are' (ft. Alicia Keys)
10. 'It Girl'

Happy Vibes

» **Still to this day, the female achievement goes mostly ignored and overlooked. That's something we need to change.** »

Pharrell, on *The Ellen DeGeneres Show*, 5 January 2017

Pharrell Williams

Did Someone Say 'Happy'?

Pharrell wrote the utterly infectious song 'Happy' for the film *Despicable Me 2*, and originally didn't plan to take lead vocals.

Pharrell revealed that he wrote the song with CeeLo Green in mind as the singer – and the two even recorded his vocals.

But CeeLo had a Christmas album coming out around the same time as 'Happy' was set to drop, so his team pulled him from the project to focus on that instead, leaving Pharrell to lay down the vocals himself.

Happy Vibes

Coach Pharrell

Pharrell appeared as a coach on four seasons of *The Voice* – taking over from CeeLo Green in 2014.

He had one Coach win, in 2015, with folk singer Sawyer Fredericks.

Pharrell Williams

Dance Your Heart Out

Pharrell released 'Happy' on 2 July 2013, as part of the *Despicable Me 2* soundtrack, but it gained no traction – that is, until he released the music video to go with it.

A compilation of people of all different generations, sizes, races and classes dancing down the street, in their offices, shopping malls, classrooms and homes – it was a true celebration of joy and movement.

In his own words, that's when things exploded.

Happy Vibes

"**Zero airplay, nothing. And the next thing you know, we put out the video on November 21 and all of a sudden – boom. I mean, when I say boom, I mean *boooooom*.**"

Pharrell, interview on *Oprah Prime*, 2014

Pharrell Williams

*
'Happy' in Numbers

'Happy' gave Pharrell his best-selling single to date. Here are the song's impressive stats:

'Happy' peaked at **No. 1** on the charts in **24 countries**, including the UK, USA, New Zealand, Ireland and Canada.

It was the USA's best-selling song in 2014, with **6.45 million copies** sold.

Happy Vibes

The song rose to the No. 1 spot a **record-setting three times** in the UK.

'Happy' is the **eighth highest-selling single of all time** in the UK.

Fans of the song started a trend of making their own music videos for the track, typically featuring them gleefully dancing to it.

As of 2024, Pharrell's original music video for 'Happy' has **1.3 billion views**.

Pharrell Williams

> **It's overwhelming because it's like I love what I do and I just appreciate the fact that people have believed in me for so long.**

Pharrell, on the success of 'Happy', interview on *Oprah Prime*, 2014

Happy Vibes

Happy Cameos

The 'Happy' music video was peppered with celebs, including …

Magic Johnson, Steve Cantrell, Jamie Foxx, Kelly Osbourne, Sérgio Mendes, Jimmy Kimmel, Ana Ortiz, Miranda Cosgrove, Gavin DeGraw and JoJo

… as well as a fair few Minions, of course.

Pharrell Williams

The Grammys Say it's a Winner

At the 57th Annual Grammy Awards in 2015, Pharrell took home a trio of statues for his work on 'Happy', as well as his second studio album, *G I R L*:

- **Best Urban Contemporary Album**
- **Best Pop Solo Performance for 'Happy'**
- **Best Music Video for 'Happy'**

Happy Vibes

\\ Some people say there's nothing new under the sun. I still think that there's room to create, you know. And intuition doesn't necessarily come from under this sun. It comes from within. \\

Pharrell, interview with Talk Asia,
20 December 2013

Pharrell Williams

In 2020, Pharrell was inducted into the Songwriters Hall of Fame for his work as the Neptunes.

Happy Vibes

"Life without music would be like a human being without sense."

Pharrell, interview in the
Guardian, 12 January 2023

Chapter Four
Cultural Icon

Pharrell Williams

"Fashion is a Way."

Pharrell, interview in *Vogue*,
15 February 2023

Cultural Icon

More Than a Side Hustle

With Pharrell's incredible music career laid out, it's hard to believe he had any time for anything else.

But over the years, Pharrell has become just as well known for his quirky fashion choices and stand-out viral red-carpet looks as he is for his chart-toppers.

Pharrell Williams

"Fashion has to reflect who you are, what you feel at the moment, and where you're going. It doesn't have to be bright, it doesn't have to be loud. Just has to be you."

Pharrell, interview in GQ, 2014

Cultural Icon

Early Days

In 2003, Pharrell founded two clothing labels with friend (and Japanese streetwear pioneer) Nigo: Billionaire Boys Club and Ice Cream (known collectively as BBC Ice Cream).

These ventures made one thing very clear: Pharrell could effortlessly bring together streetwear and luxury fashion, while at the same time influencing musical and cultural trends.

Pharrell Williams

Life Before Ralph

In a 2013 interview, Pharrell was asked if he could divide his life into "pre-Ralph Lauren silver jacket" and life after discovering the outerwear.

The story goes that Pharrell scrimped and saved to buy a silver double-breasted Ralph Lauren Polo jacket from their 2000 ski collection. And when, eventually, he bought the item, everything changed for him.

Laughing, Pharrell agreed that perhaps purchasing this aspirational piece did line up with a turn in his fortunes – and recalled his desire to collect high fashion attire even during his humble beginnings.

Cultural Icon

> **Polo has always been a staple in my community. It's aspirational.**

Pharrell, interview on CNN,
20 December 2013

Pharrell Williams

LV meets PW

Pharrell shot into the high fashion world in 2004 with a massive collab.

Alongside friend and business partner Nigo, and at the request of then-creative director Marc Jacobs, the duo designed a pair of sunglasses for luxury brand Louis Vuitton. The shades were named Millionaires – and they became a hip-hop style staple of the 2000s.

The now-iconic glasses have the shape of an oversized classic aviator, and have been described as "one part Tony Montana, one part the Notorious B.I.G.".

Cultural Icon

Pharrell reportedly drew inspiration from the hardware on Louis Vuitton's luggage when adding the hinges to the arms of his Millionaires sunglasses.

He also popped a gold bar across the top of the sunnies, one final feature to catch the light – and turn heads – which these truly did.

Twenty years after their creation, the Millionaires style has been relaunched (with Pharrell now at LV's creative helm).

Pharrell Williams

» **Collaboration is like a crash course most of the time, when I'm learning something new. It's like a crash course into whatever item, object or artistic discipline that we're working on at that time. It just allows me to learn.** «

Pharrell, interview in *Clash*,
7 September 2018

Cultural Icon

The Collabs Stack Up

Over the years, Pharrell has collaborated with a slew of fashion brands and famous designers, including:

- **Moncler**
- **Louis Vuitton**
- **Reebok**
- **Moynat**
- **G-Star**
- **Adidas**
- **Chanel (and Karl Lagerfeld)**
- **Tiffany**
- **Uniqlo**

Pharrell Williams

Iconic Pharrell #1

Face in Diamonds

Heavy is the crown (or necklace) of a musical legend – and Pharrell stayed true to his hip-hop roots when he performed at the American Music Awards in 2005, adorned with three oversized Jacob & Co. diamond chains.

One of the medallions featured a 3D figure of Pharrell alongside his two other N.E.R.D. bandmates, encrusted with pink, yellow and blue diamonds.

Cultural Icon

"Style is about who you are, where you're going, what's comfortable. It's your attitude that makes it hot."

Pharrell, interview in
Paper, 14 June 2008

Pharrell Williams

» **Don't call it a murse. It's not a man purse. It's my travel bag.** «

Pharrell, interview in
Paper, 14 June 2008

Cultural Icon

Iconic Pharrell #2

Purple Crocodile?

In 2007, Pharrell stepped out with an oversized purple Birkin.

The one-of-a-kind crocodile skin Hermès Haut à Courroies bag had been personally commissioned by Pharrell. Empty, the bag weighed 10 pounds (4.5 kilogrammes).

The bag (and Pharrell) later graced the cover of *Paper* magazine's summer 2008 edition.

Pharrell Williams

Iconic Pharrell #3

That Hat

When Pharrell attended the Grammys in 2014, he sparked both a new trend in the world of fashion – and a slew of internet memes.

Donning jeans and a red leather Adidas tracksuit top, Pharrell finished the laid-back look with a Vivienne Westwood oversized dimpled brown fedora, likened to the kind of hats Canadian Mounties wear (and the logo of sandwich chain Arby's).

The hat's been referred to by various names over the years, including: the Big Hat, Mountain Hat, Buffalo Hat and the Jelly Mould Hat!

Cultural Icon

Legend has it that Pharrell bought his original Big Hat in the early 2000s for around £70 ($100) from Vivienne Westwood's boutique on London's King's Road.

The hat was reportedly inspired by Peruvian women's hats and New York's breakdancing B-Boys from the 1980s, as well as Westwood's 1982 Buffalo Girls collection.

///

Pharrell Williams

Pharrell first stepped out in a pair of Lanvin dress shorts at the 2014 Oscars. He paired the shorts with a black jacket, white shirt and bow tie for the red carpet – and then changed into his trademark Big Hat and tracksuit for his performance of 'Happy'.

Cultural Icon

Iconic Pharrell #4

Shorts Longevity

One item of clothing that is synonymous with Pharrell are his penchant for "school-boy"-style shorts.

Styling them smart or casual, and always cut just above the knee, shorts are a staple of his wardrobe.

He's graced many a red carpet with a clean-cut suit jacket and smart dress shorts. Usually some pull-up sports socks complete the outfit.

Pharrell Williams

"I'm not a style icon. I'm just inspired. And I'm OK with that."

Pharrell, at the 2015 CFDA Awards,
CNN, June 2015

Cultural Icon

It's Official

In 2015 Pharrell was named Fashion Icon of the year at the Council of Fashion Designers of American (CFDA) prestigious awards. Diane von Furstenberg, President of the CFDA said:

"If cool was a person, it would be Pharrell, not just for his looks and sense of style but for his kindness and openness. I cannot imagine anyone not seduced by him."

Pharrell Williams

Black Ambition

In 2020, Pharrell founded non-profit initiative Black Ambition to "level the playing field" and support business owners from Black and Latinx communities. Each year there's up to $1 million to be won in this life-changing prize competition.

To date, the organization has trained 750 entrepreneurs and awarded nearly $10 million in growth capital to 101 founders.

Cultural Icon

> **Ensuring that every citizen has the same opportunity to succeed and flourish – regardless of class, gender or skin color… is the only way to guarantee life, liberty and the pursuit of happiness.**

Pharrell, *Time*, 20 August 2020

Pharrell Williams

The Time Has Come

In December 2022 Pharrell received a text from Alexandre Arnault, the heir to the French luxury goods group Moët Hennessy Louis Vuitton (LVMH). The message simply read:

**"Please call me.
The time has come."**

(And, no, Arnault was not thinking about recording a track with Pharrell as producer.)

Pharrell had already tried to push the brand to hire his long-time fashion collaborator, Nigo, for a role at Louis Vuitton, which was in need of a creative director for its men's division. But Arnault had someone else in mind.

Cultural Icon

In 2023 it was announced that Pharrell would become Louis Vuitton's new men's creative director.

Louis Vuitton released a statement saying Pharrell is a:

**\\ ...visionary whose creative universes expand from music to art, and to fashion. **

Pharrell Williams

Always Learning

Pharrell's work with Louis Vuitton has, so far, been met with critical acclaim. But some critics initially questioned whether the music producer with no official fashion qualifications could follow in the footsteps of fashion legend Virgil Abloh.

Thankfully, Pharrell takes a refreshing approach to his position, seeing himself as a constant student, and not a master:

"A ruler of a position is usually like a king. But a ruler of this position for me is a perpetual student. It's what I intend to be. […] I am a creative designer from the perspective of the consumer. I didn't go to Central Saint Martins. But I definitely went in the stores and purchased, and I know what I like."

Pharrell, interview in *The New York Times*, 18 June 2023

Cultural Icon

Joopiter Rising

In 2022 Pharrell created online auction site Joopiter, with a focus on "rare cultural objects".

Joopiter's inaugural auction comprised 52 items from Pharrell's personal stash, including a gold-plated Blackberry, an 18-carat gold-plated PlayStation console and gold-plated Oakley sunglasses.

The first collection raked in over $5 million (£3.8 million), with a portion going to Black Ambition (the non-profit founded by Pharrell in 2020).

Pharrell Williams

$1 Million

A staple of Pharrell's debut collection for Louis Vuitton was the bold, bejewelled Speedy bag.

Setting you back a cool one mil, the buttery soft handmade leather bag – available in four primary colours – has chunky gold hardware with diamond-encrusted pendants.

Cultural Icon

Pharrell's first ad campaign for Louis Vuitton was nothing but a statement: a heavily pregnant Rhianna posed with her shirt half open, exposing her bump, carrying a coffee and several brightly coloured Louis Vuitton Speedy bags.

In an interview on 18 June 2023, Pharrell told *The New York Times*:

〝 What I love about this is, it's the biggest fashion house in the world, and that is a Black woman with child. 〞

Pharrell Williams

"Tiffany and I are Engaged"

In 2024, Pharrell somehow found the time to launch his first ever jewellery collection with Tiffany & Co., announcing on his social media that "Tiffany and I are engaged".

The 19-piece yellow gold and black titanium collection Tiffany Titan drew inspiration from the mythological Poseidon's trident. The collection is bold and chunky, with sharp features and spear-like spikes. Pharrell explained:

"The detail in all of the jewellery pieces is very intentional, the use of black titanium … it's a physical manifestation of beauty in Blackness."

Cultural Icon

> "I think my current settings, my current modus operandi, is about moving forward, making sure anything I do just feels like it's timeless."

Pharrell, interview in *Clash*,
7 September 2018

Pharrell Williams

Teardrops of Gold

Gone are the oversized sunnies of the early 2000s – Pharrell's latest viral headwear consists of small, teardrop-shaped 18-carat gold shades, encrusted with 61 diamonds and two emeralds.

Cultural Icon

> **I could have been anywhere, but I'm here. It was written that I'm here. So I'm just very grateful. […] I really do feel it down to the very fibre of my being.**

Pharrell, interview in GQ, 2023

Pharrell Williams

"**Creativity to me is a means of expression. It's a gift from the all that is, all that was and all that ever will be; the creator. We're co-creators.**"

Pharrell, interview in *Clash*, 2018